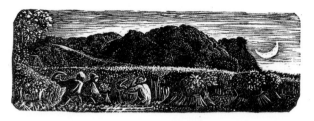

Harvest under a waning Moon
Woodcut, *c.* 1827

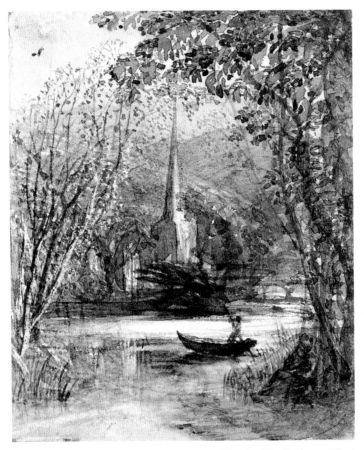

Church with a Bridge and Boat
c. 1830

Ashmolean handbooks

Samuel Palmer

Colin Harrison

Ashmolean Museum Oxford
1997

Published with the aid of a generous grant
from Hazlitt, Gooden and Fox

Text and illustrations © The University of Oxford:
Ashmolean Museum, Oxford 1997
ISBN 1 85444 100 0 (papercased)
ISBN 1 85444 101 9 (paperback)

Titles in this series include:
Ruskin 's drawings
Worcester porcelain
Italian maiolica
Drawings by Michelangelo and Raphael
Oxford and the Pre-Raphaelites
Islamic ceramics
Indian paintings from Oxford collections
Camille Pissarro and his family
Eighteenth-century French porcelain
Miniatures

British Library Cataloguing in Publication Data
A catalogue record for this book is available from the
British Library

Cover illustration: *Shepherds under a full Moon*, no. 15

Designed and typeset in Versailles by Roy Cole
Printed and bound in Singapore by Craft Print Pte Ltd

Contents

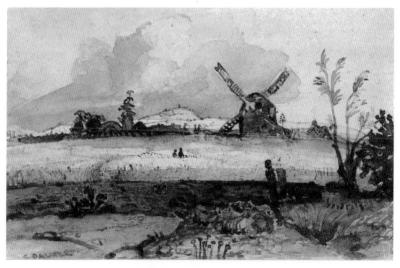

Landscape with a Windmill beyond a Cornfield
Pen and brush in brown ink, 6.8 × 10.4 cm
Signed and dated, lower left, *S PALMER*
Bequeathed by Francis Falconer Madan, 1962 [1962.17.72]
Grigson 51; Brown 11; Lister 65

Introduction

The art of Samuel Palmer is essentially a discovery
of the twentieth century. Although he exhibited
widely during his lifetime, and found buyers for
some of his watercolours and etchings, it was not
until the retrospective exhibition held at the Victoria
and Albert Museum in 1926 that the general public
were able to enter the uniquely personal world of
Palmer's early years at Shoreham. Since then, his in-
fluence on a generation of English painters includ-
ing Nash, Sutherland, John Piper, and F.L.Griggs,
the publications of Geoffrey Grigson, Raymond
Lister and others, have made him one of the most
popular of English artists.

Palmer was born into comfortable circumstan-
ces in 1805. He was a bookish child, his favourite
reading being Bunyan's *Pilgrim's Progress* and the
Bible, and both imbued in him a deep sense of the
miracle of the Creation. He grew up to be sensitive
and highly strung, prone to melancholy and fits of
depression, but also to periods of sustained ecstasy
and creative energy. Profoundly reactionary, he was
impatient of modern life, claiming that 'the Past was
for Poets, the Present for Pigs'. He found his most
sympathetic surroundings in the village of Shore-
ham, in the Darent valley, where he lived between
c. 1825 and 1835. There, although only twenty miles
from London, he was able to shut himself off from
all that was hateful, and produced his most intensely
personal and 'visionary' work. At Shoreham, he
was surrounded by a small group of young men, in-
cluding the painters George Richmond and Edward
Calvert, who called themselves 'The Ancients' be-
cause they looked not to their contemporaries for
example but to Northern artists such as Lucas van

Leyden and Dürer. Their strange activities and nocturnal habits earned them the name 'extologers' in the village. They also looked to William Blake, whom Palmer met in 1824 and whom he revered above all other artists. Among the products of this early phase, the six sepia drawings (nos. 5–10) are the most inspired illustrations of Palmer's neo-Platonic vision of an earthly Paradise.

Palmer was unable to sustain this intense interior life, as the cares of domesticity encroached on his art. For much of his life, he was 'pinched by a most unpoetical and unpastoral kind of poverty', and the responsibilities of a wife and children increased his anxiety. Although he exhibited regularly at the Royal Academy, the British Institution and the Old Watercolour Society, he was unable to make a living from selling his works, and took to teaching, which by 1848 accounted for nearly half his income, his pupils generally being young ladies anxious to be thought of as 'accomplished'. His work became increasingly uneven, but at its best, such as *Tintagel Castle* (no. 33), it is distinctive and extremely powerful. His experiments with etching, begun in 1850 and continuing to his death in 1881, consciously attempted to recover the intensity of his Shoreham years, and the Milton series, in particular (nos. 36–7), and their associated watercolours, are remarkably successful.

The Ashmolean is fortunate in possessing a uniquely representative collection of Palmer's Shoreham pictures, mostly acquired long before his fame and popularity on the art market reached their present levels. Two were acquired for the museum by Kenneth Clark (nos. 3–4), but the majority by K.T. Parker during his period as Keeper of the Department of Fine Art (1934–1961). The set of six sepia drawings, for example, cost £300 in 1941! Today, we cannot hope to acquire Palmer's works by purchase, but it is particularly gratifying that notable additions are made by gift, such as the oil painting, *The White Cloud* (no. 19), and the sketch of *Corpo di Cava* (no. 24).

1 *Study of a Cottage*
Brush in brown wash on buff paper, 6 × 10.3 cm
Purchased, 1954 [1954.101]
Grigson 15; Brown 1; Lister 17

2 *Study of a Cottage*
Brush in brown wash on buff paper, 6.1 × 10.1 cm
Purchased, 1954 [1954.102]
Grigson 15; Brown 2; Lister 17

Palmer was a precocious artist, exhibiting his first work at the British Institution and the Royal Academy in 1814, when he was only eleven. His first drawing master was the obscure artist, William Wate, who probably taught from manuals such as David Cox's *Treatise on Landscape Painting and Effect in Watercolour*, of 1813. His earliest surviving work is timid and conventional, but he must have made rapid progress, for a sketchbook dated 1819 (British Museum) is both more accomplished and more individual.

These two drawings of cottages were probably made on Palmer's early sketching expeditions in London and the Home Counties, and rely solely on brown ink, without preliminary work in pencil. Brown is the colour of the prints in Earlom's publication of Claude's *Liber Veritatis* and in Turner's *Liber Studiorum*, which Palmer admired. His use of monochrome, for both sketches and finished pictures, enabled him to concentrate on form and texture, and gave his early work an archaic feeling.

Palmer met John Linnell in 1822, and, under his guidance, quickly turned away from Cox's tradition, noting after a visit to Dulwich in 1824 that 'Cox is pretty, is sweet, but is not grand, not profound.'

9

3 *Self Portrait*
Black chalk heightened with white on buff paper,
29.1 × 22.9 cm
Purchased (Hope Collection), 1932 [1932.211]
Grigson 58; Brown 3; Lister 63

During his youth, Palmer had been 'a bit of a dandy for
a time . . . bedecking himself in white trousers and flour-
ishing a whangee cane.' He later abandoned this extrav-
agance for more practical attire, and generally wore 'a
loose and lengthy broadcloth coat of a rather peculiar
cut . . . a double-breasted waistcoat, buttoned high and
close over the formal folds of an old-fashioned white
cravat', which gave him a rather clerical appearance.
This was emphasised at Shoreham: his fellow Ancient,
F.O.Finch, described him as 'remarkable for a certain
baldness over the forehead which, added to a flowing
beard (a thing to be looked at in those days), together
with a cloak down almost to the heels, gave to passers-
by the appearance of an apparition, by no means an
unpleasant one, but certainly not youthful.'
 Palmer made only a handful of portraits, all early
in his career. This penetrating and hypnotic self portrait
probably dates from *c.* 1824–5, at about the time he be-
gan to visit Shoreham, and may have been the *Study of
a Head* he exhibited at the Royal Academy in 1824. It
shows a remarkably assured and free use of black chalk,
in the tousled hair, and sensitive eyes and lips, and the
determination of the jaw. A strong overhead source of
light is reflected in the forehead and bridge of the nose,
which, together with the slight tiredness about the eyes
and the dark shadow of beard on the upper lip and chin,
suggest that the drawing was made late at night.

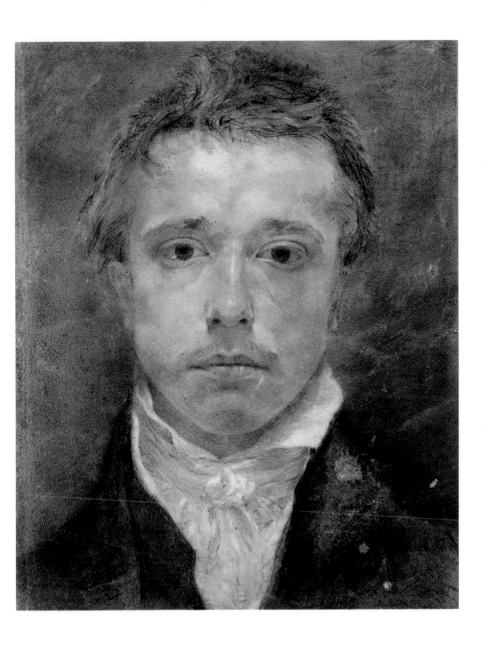

4 *The Repose of the Holy Family*
Oil and tempera over pen and Indian ink, on panel,
31 × 39 cm
Presented by the National Art Collections Fund, 1932
[1932.2]
Grigson 30; Brown 4; Lister 46

Linnell introduced Palmer to the aged William Blake in
1824, and the momentous meeting encouraged the
young artist to develop a peculiarly intense imaginative
vision. The sketchbook Palmer began in 1824 (most
sheets in the British Museum) illustrates this new way of
seeing, and contains the germs of many of the paintings
and drawings he made at Shoreham. This *Repose of the
Holy Family* was one of Palmer's first attempts in oils,
and it preoccupied him to the point of despair during
the winter of 1824–5: he noted on 2 January 1825 that 'I
have laid by the *Family* in much distress, anxiety and
fear: which had plunged me into despair but for God's
mercy . . . but rather, distress (being blessed) was to me
a great arousement; quickly goading me to deep hum-
bleness, eager, restless inquiry, and diligent work.'
 In depicting this most traditional of religious sub-
jects, Palmer identified himself with the Old Masters.
The composition is reminiscent of prints by Dürer,
Schongauer, and Claude, which Palmer greatly ad-
mired. Apart from a general debt to these artists, there
is a specific borrowing in the donkey, which is taken
from Blake's *Holy Family* and his print *Hecate*, and was
ultimately derived from an illustration in Alexander
Browne's *Ars poetica* (1675). Palmer's technique is idio-
syncratic: most of the composition is drawn in pen and
ink on a white ground, reworked in thin oil paint and
heightened with brilliant, jewel-like strokes of tempera
mixed with gum.
 Like much of Palmer's early work, this picture
failed to sell, and was bought by his cousin and fellow
Ancient, John Giles, in the 1860s.

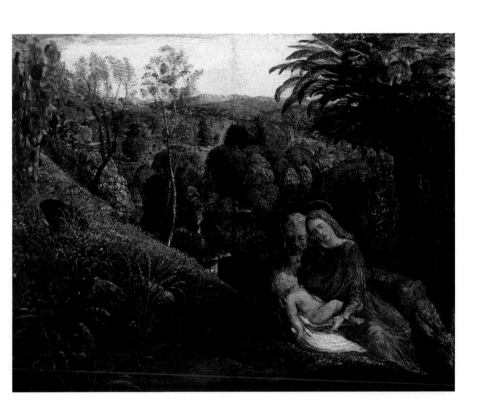

5 *Rustic Scene*
Pen and brush in dark brown ink mixed with gum, varnished, 17.9 × 23.5 cm
Signed and dated, lower right, Samuel Palmer 1825
Purchased, 1941 [1941.102]
Grigson 38; Brown 5; Lister 53

In 1909, Palmer's son made a sacrificial bonfire of his father's early sketchbooks, letters and even paintings he had inherited, 'knowing that no one would be able to make head nor tail of it'. The six sepia drawings in the Ashmolean survive because they were given or sold by the artist to John Giles's junior partner, J.W.Overbury. Originally, they were contained in one frame, the mount inscribed by Palmer with quotations from poetry evoking the pastoral mood of each scene. That to *A Rustic Scene* was taken from Virgil's *Georgics* (Book I, ll. 208–11), exhorting the farmer to take advantage of autumn for sowing.

The technique of these works is unique: Palmer has used a fine pen to draw in minute detail every element of the composition, and has mixed the dark brown ink with gum to give the thick outlines the relief found in etchings and some woodcuts. The addition of varnish unifies the composition, and gives the drawings the appearance of carved ivories, which has increased with age.

Many details in these drawings are reminiscent of Blake's woodcuts to Thornton's edition of the *Pastorals of Virgil*, which Palmer described in words that might equally apply to his own drawings: they are 'visions of little dells, and nooks, and corners of Paradise; models of the exquisitest pitch of intense poetry . . . There is in all such a mystic and dreamy glimmer as penetrates and kindles the inmost soul, and gives complete and unreserved delight, unlike the gaudy daylight of this world.'

14

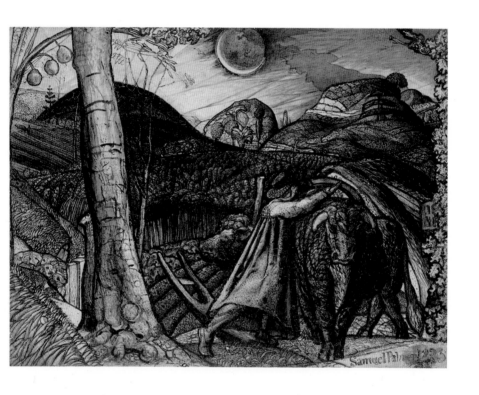

6 *Early Morning*
Pen and brush in dark brown ink mixed with gum, varnished, 18.8 × 23.2 cm
Signed and dated, lower centre, *SAMUEL PALMER 1825*
Purchased, 1941 [1941.107]
Grigson 40; Brown 10; Lister 55

The quotation written beneath this scene was taken from Lydgate's *Complaint of the Black Knight*, then attributed to Chaucer: 'I rose anon, & thought I would gone / Into the wode to heare the birdes sing, / When that misty vapour was agone, / And clear & faire was the morning. Chaucer.'

In the stillness of dawn, a hare hops up a path. In the middle distance, a group of villagers sits beneath a chestnut tree at the edge of a cornfield. Behind, the rounded thatch of cottages mingles on the horizon with distant hills. Everywhere is abundance and variety, as the rising sun casts long shadows on the ground.

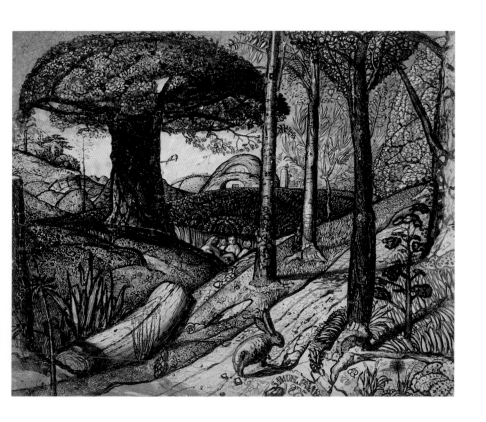

7 *The Valley with a bright Cloud*
Pen and brush in dark brown ink mixed with gum, varnished, 18.4 × 27.8 cm
Signed and dated, lower left, *SAMUEL PALMER 1825*
Purchased, 1941 [1941.105]
Grigson 39; Brown 8; Lister 54

Palmer's quotation for this scene read: 'This our life, exempt from public haunt, Finds tongues in trees, books in ye running brooks, Sermons in stones, and good in everything. *As you like it'*. It is the only one of this group not to include the human figure, although the prominence of the church in the background evokes his constant presence. As Palmer noted, 'Landscape is of little value, but as it hints or expresses the haunts or doings of man. However gorgeous, it can be but Paradise without an Adam. Take away its churches, where for centuries the pure word of God has been read to the poor . . . and you have a frightful kind of Paradise left – a Paradise without a God.'

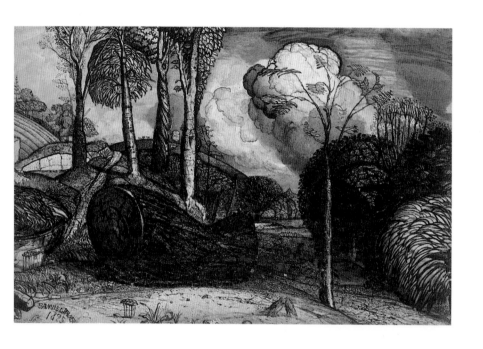

19

8 *The Skirts of a Wood*
Pen and brush in dark brown ink mixed with gum, varnished, 17.4 × 27.7 cm
Dated, lower right, *1825*
Purchased, 1941 [1941.106]
Grigson 42; Brown 9; Lister 57

Palmer's work was regularly accepted by the Royal Academy for their annual exhibitions, and the few contemporaries who commented on it were bewildered rather than hostile. Of his showing in 1825, one writer remarked that 'We think that if he would show himself with a label round his neck "The Painter of *A View in Kent*", he would make something of it at a shilling a head.' No doubt he would have said the same of *The Skirts of a Wood*, exhibited in 1826, whose neo-Platonic vision of man and nature would have been comprehensible only to Blake and Palmer's fellow Ancients. The composition depends on two works by Blake, the woodcut frontispiece to his illustrations to *The Book of Job*, and the watercolour illustration to Dante, *Homer and the Ancient Poets*. However, Palmer has ignored the pessimism of Blake's designs, and transformed them into a scene of undisturbed peace and contentment.

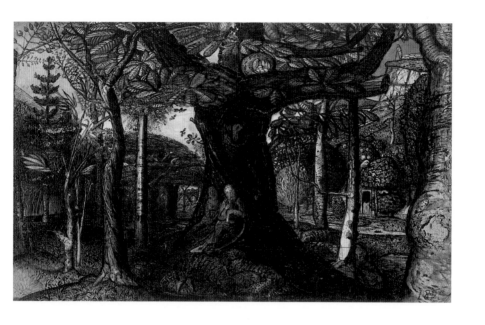

9 *The Valley thick with Corn*
Pen and brush in dark brown ink mixed with gum, varnished, 18.2 × 27.5 cm
Signed and dated, lower centre, *SAMUEL PALMER*
Purchased, 1941 [1941.103]
Grigson 43; Brown 6; Lister 58

This is the first of many compositions which developed from an idea in Palmer's sketchbook of 1824–5: 'A large field of corn would be very pretty with as it were islands peeping out of it – a clump of cottages completely inclosed a shaded by trees – the corn being high, no part of the little isles in this waving sea of plenty would be seen till they were perhaps 5 or six feet from the ground – only a clump of elm trees rising distinctly from the midst would be pretty . . . and over the distant line that bounds this golden sea might peep up elysian hills, the little hills of David, or the hills of Dulwich or other visions of a better country which the Dulwich fields will shew to all true poets.' Palmer's commentary on the old mount read:

> Thou crownest ye year with thy goodness; and
> the cloud drop fatness. They drop upon ye dwel-
> lings of ye wilderness: and ye little hills shall
> rejoice on every side. The folds shall be full of
> sheep; the vallies also shall stand so thick with
> them that they shall laugh and sing.
> LXV. PSALM

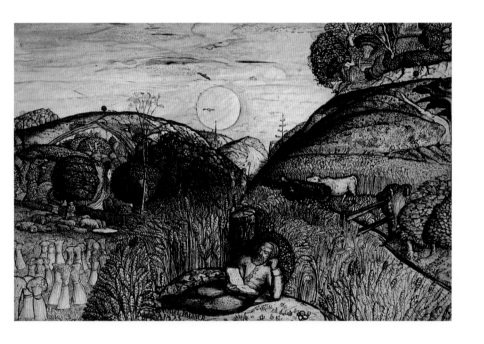

10 *Late Twilight*
Pen and brush in dark brown ink mixed with gum, varnished, 18 × 23.8 cm
Purchased, 1941 [1941.104]
Grigson 41; Brown 7; Lister 56

Palmer's caption for this drawing included a quotation from *Macbeth* (Act III, scene 3), which he mistakenly attributed to Milton: 'LATE TWILIGHT The West yet glimmers with some streaks of day. Milton'.

Late Twilight is the most poetic and mysterious of these six drawings of 1825. Under the strong light of the crescent moon, a shepherd sleeps on the backs of his sheep, watched over by an owl, while a rabbit feeds undisturbed in the foreground. Behind is a field of corn, much of it gathered into sheaves; beyond, a thatched cottage and church among the trees. It seems that Palmer intended this peaceful scene to be viewed as a vision of Beulah, the paradise within sight of the Heavenly City, whose people live in complete harmony with nature. Certainly, the literary sources, in Bunyan's *Pilgrim's Progress* and the Book of Isaiah, were well known to Palmer and to Blake, and it is possible that all six of these designs were intended to be evocations of specific literary passages.

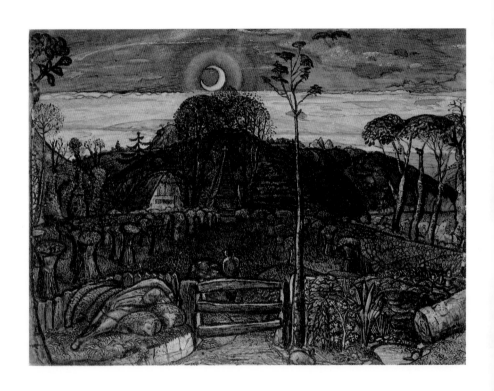

11 *View of Shoreham*
Pen and brush in black and grey inks and washes,
heightened with white body colour, over indications in
pencil, on grey paper, 22.8 × 30 cm
Presented by Miss A.B.M.Ronald, 1977 [1977.223]
Brown 13; Lister 95

The drawing is inscribed by A.H.Palmer, 'Sketch by
Samuel Palmer of the village of Shoreham near Seven-
oaks. Here it was that Palmer spent the happiest years
of his life; all that he saw & wrote & drew being trans-
muted & changed by Blake's direct personal influence'.
 Palmer seems to have first visited Shoreham in
1824, and moved there permanently with his father and
nurse at some time in the following year, using a legacy
from one of his grandfathers to buy a house. He even-
tually owned no fewer than five cottages in the village,
which provided him with a small annual income.
 This view is taken from the west of Shoreham,
and shows Waterhouse, where Palmer lived with his
father, slightly to the left of centre, in front of a clump of
trees. It is rapidly drawn in pencil, carefully worked up
in ink, with a few highlights added in white.
 Such sketches from nature were inspired by the
example of John Linnell, who told Palmer that he could
earn £1,000 a year from making studies of the scenery at
Shoreham. However, as Palmer wrote to George Rich-
mond in September 1828, 'by God's help I will not sell
away His gift of art for money; no, not for fame neither,
which is far better . . . Tho' I am making studies for Mr
Linnell, I will, God help me, never be a naturalist by pro-
fession.'

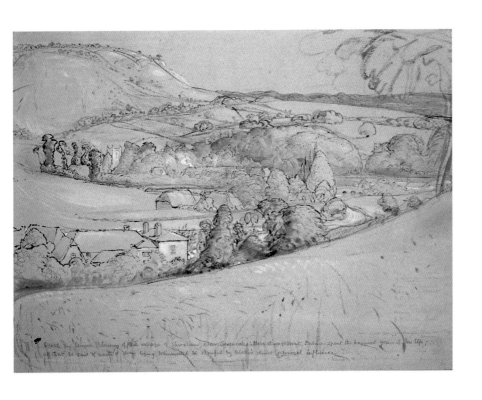

Sketch by Samuel Palmer of the village of Shoreham, near Sevenoaks. Here throughout Palmer spent the happiest years of his life; all that he saw & wrote of them being transmuted & transfigured by Blake's direct personal influence.

12 *Barn in a Valley; Sepham Barn*
Pen and brush in brown and Indian inks, heightened
with white body colour, over pencil, on buff paper,
28.1 × 44.5 cm
Signed, lower right, *S. Palmer*
Purchased, 1938 [1938.101]
Grigson 65; Brown 12; Lister 91

In a letter to Linnell of 1828, Palmer made a distinction
between 'general nature', which 'is wisely and benefi-
cently adapted to refresh the senses and sooth the spir-
its of general observers', and nature interpreted by the
visionary artist, as 'divine Art piles mountains upon
[Nature's] hills'. His nature studies increasingly came to
neglect the latter aspect, but at Shoreham still have the
character of 'Imaginative Art'. Here, the barn on Sep-
ham Farm, to the south-west of Shoreham, crouches
beside a haystack at the edge of a sweeping curved field.
Dark wooded hills behind are relieved by a few touches
of white bodycolour in the sky, the farm buildings and
the foreground. The field is bordered by the swirling
scribble of trees, and the foreground characteristically
left empty.
 This drawing was first owned by Linnell, who
visited Palmer at Shoreham in 1828.

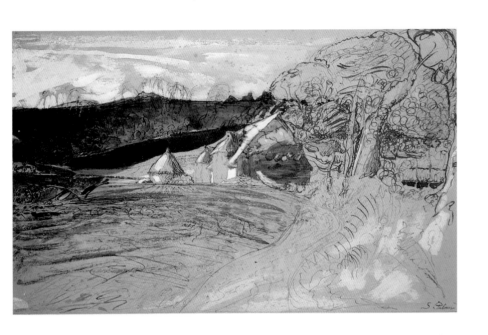

29

13 *Ivy Cottage, Shoreham*
Water and body colours with gum arabic over pencil
and pen and brown ink, with scratching out,
40 × 31.9 cm (IMP)
Purchased, 1942 [1942.113]
Grigson 97; Brown 15; Lister 132

Palmer seems to have lodged at Ivy Cottage, in the main
street at Shoreham, on his early visits in 1824–5. Later,
he made at least two drawings of the house, one realis-
tic and detailed, probably made in 1828 (Yale Center for
British Art, New Haven), and the other, this large and
roughly drawn example, three or four years later. Here,
the cottage is glimpsed through trees, the sun shining
on its brilliantly white-washed walls and red roofs. In
the garden, a group of figures sits in the shade, one with
a rustic straw hat, another wearing a red shawl. At the
edge of the garden, sheep complete the picture of rustic
contentment.
 This drawing is notable for the range of tech-
niques Palmer has used, from the vigorous under-draw-
ing in pencil and pen, the broad washes in the grass and
sky, to the shorter strokes in the foliage, culminating in
the stippling with thick bodycolour in the tree nearest
the house.

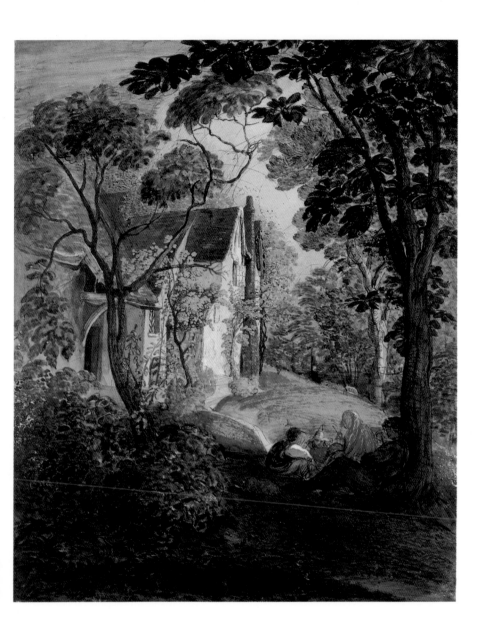

14 *Pastoral with a Horse Chestnut Tree*
Water and body colours with gum arabic and height-
ened with white over indications in pencil,
33.4 × 26.8 cm
Bequeathed by the Revd William Fothergill Robinson
through the National Art Collections Fund, 1929
[1929.37]
Grigson 96; Brown 14; Lister 131

Palmer noted in 1825 that 'Excess is the essential vivi-
fying spirit, vital spark, embalming spice . . . of the finest
art'. One way this excess manifested itself in his own art
was in the exaggerated abundance of nature, of crops of
grain and fruit or of flowers. The *Pastoral with a Horse
Chestnut* is the last of a group of watercolours made
over several years at Shoreham which exemplify this
theme; among others are *In a Shoreham Garden* of
c. 1829 (Victoria and Albert Museum) and, most notably,
the celebrated *Magic Apple Tree* of 1830 (Fitzwilliam
Museum, Cambridge). The Ashmolean picture is techni-
cally the most controlled of the group, and probably
dates from *c.* 1832. The subject of the horse chestnut
had fascinated Palmer since 1824–5, when he made
detailed studies of the leaves in his sketchbook. Here,
the exaggerated size of the leaves and candles of flow-
ers gives a supernatural appearance, while the cosy
forms of the sheep and piping shepherdess add a time-
less charm.
 In later life, Palmer told his pupils that, for study,
'a cedar and a chestnut are just the best trees you could
be employed upon'.

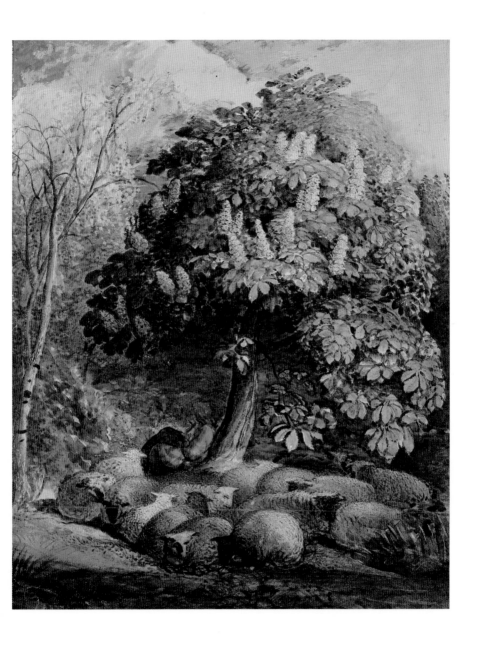

15 *Shepherds under a full Moon*
Pen and brown ink and brush in Indian ink mixed with
gum, heightened with body colour on white card,
11.8 × 13.4 cm
Purchased, 1934 [1934.287]
Grigson 87; Brown 18; Lister 118

Parallel with his experiments with high colour at Shore-
ham, Palmer continued to explore the possibilities of
monochrome, exhibiting a group of what he referred to
as 'blacks' at the Royal Academy in 1832, which prob-
ably included nos. 16–18. *Shepherds under a full Moon*
may be the precursor of the series, with the thick out-
lines strengthened in gum resuming the technique of
the sepia drawings of 1825. The composition is also
strongly indebted to the first of Blake's woodcuts to
Thornton's Virgil, *Thenot and Colinet*, although the
mood is quite different.

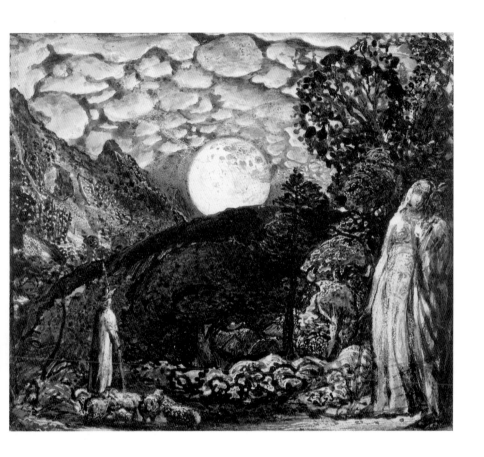

16 *A young Man yoking an Ox*
Brush in Indian ink with scratching out, 14.9 × 18.6 cm
Purchased, 1940 [1940.63]
Grigson 36; Brown 16; Lister 136

This is a reworking in Indian ink of *A Rustic Scene* of
1825 (no. 5). Most of the elements of the composition are
similar, but the effect is quite different: the scene is now
lit by a brilliant setting sun, and the mood less static, the
young man and his ox are in more animated poses, and
behind them, a pair of oxen lumber off down the hill.
The style of the painting is correspondingly freer and
less archaic, the lack of gum and varnish allowing much
greater immediacy.

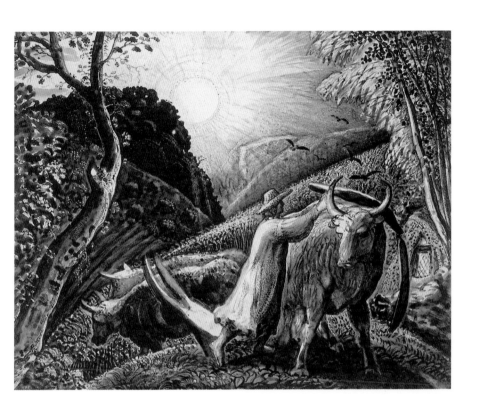

17 *The Flock and the Star*
Pen and brush in Indian ink over pencil and brown ink,
on white card, 15 × 17.7 cm
Purchased, 1940 [1940.64]
Grigson 98; Brown 17; Lister 133

Another of the 'blacks' which may have been exhibited
in 1832, and similar in technique to the preceding draw-
ing. Here, however, the brown ink seems to indicate the
beginnings of a completely different subject. Much of
the composition is defined by robust scratching out
with a knife or pen nib, so that the drawing seems to be
worked up from black to white, in reverse to the usual
procedure. The landscape is still, save for a lamb feed-
ing enthusiastically to the accompaniment of a shep-
herd's pipe.

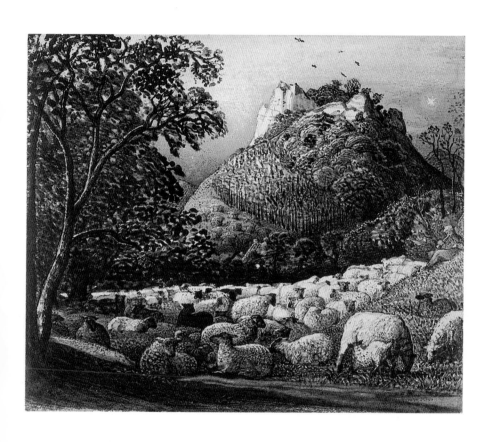

39

18 *The White Cloud*
Pen and brush in Indian ink over pencil and pen and
brown ink, with scratching out, 14.4 × 16 cm
Purchased, 1934 [1934.288]
Grigson 120; Brown 19; Lister 144

Palmer made studies of clouds in his sketchbook of
1819, not scientifically, as Constable was to do later, but
for their picturesque qualities. Such studies were in-
corporated into several works in 1825 (see no. 7), but
Palmer still felt that he had not exploited their possibili-
ties fully: as he wrote to Linnell in December, 1828,
'The glorious round clouds which you paint I do think
inimitably, are alone an example how the elements of
nature may be transmitted into the pure gold of art'.
This monochrome study is one of the 'blacks', and was
later reworked into an oil painting (no. 19), although the
drawing was conceived independently of the painting.
Again, much of the composition is defined by scratch-
ing out, and the clouds themselves by leaving the paper
blank.

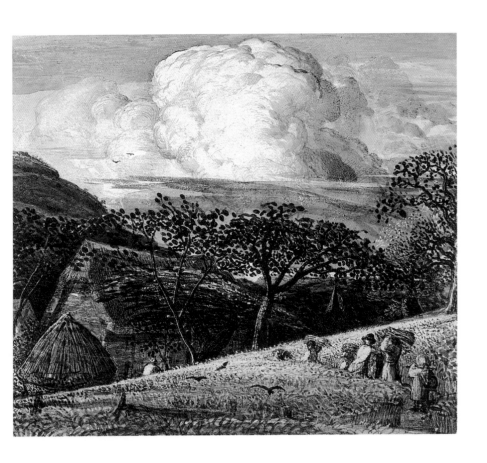

41

19 *The White Cloud*
Oil and tempera on panel, transferred to canvas,
22.2 × 26.7 cm
Bequeathed by Ian Lawrence Phillips, 1986 [1987.68]
Grigson 135; Lister 175

A reinterpretation in oils of the preceding picture, this painting was probably made a year or two later. Together with its companion, *The Bright Cloud* (Manchester City Art Gallery), which shows a similar composition in reverse, it represents the culmination of Palmer's study of clouds which began in his sketchbook of 1819.

 The White Cloud first belonged to George Richmond, whose daughter, Julia, married William Fothergill Robinson, later a Queen's Counsel and Vice Chancellor of the Duchy of Lancaster, in 1869. Richmond gave the painting to them on their twenty-fifth wedding anniversary in 1894.

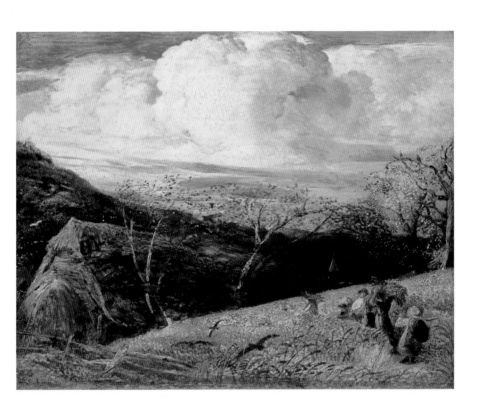

43

20 *Cornfield bordered by Trees*
Oil and tempera on panel, 17 × 14.5 cm
Purchased, 1947 [1947.168]
Brown 21; Lister 171

During the early 1830s, Palmer's natural restlessness
asserted itself, and he gradually tired of the rural
charms of Shoreham. He bought a house at Lisson
Grove in 1832, and went on extended sketching tours, to
Devon in 1834, Wales and Devon in the following year,
and left Shoreham for good in 1836.

This small painting was probably one of the last
made at Shoreham. It shows the favourite composition
of a cornfield sloping diagonally in the foreground, and
a small house nestling in a hollow in the centre. A flock
of sheep winds through the cornfield, followed by a
waggon drawn by a pair of horses, and preceded by
cattle and a shepherd in a red bonnet carrying a staff.
The rather sombre colouring has probably darkened
with age, but this may be, as Brown suggests, a rare
example of an oil sketch.

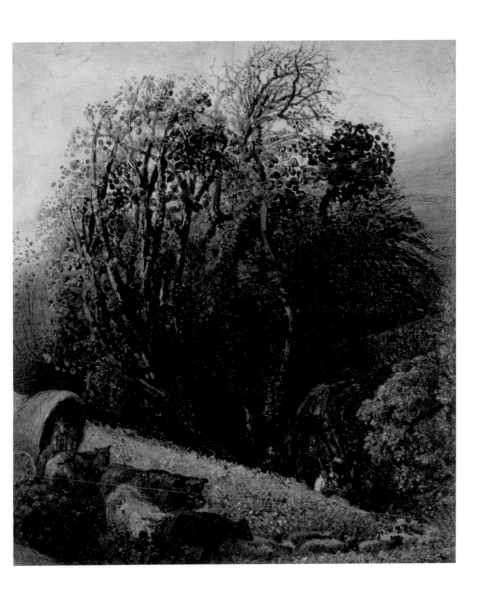

21 *Pastoral Scene*
Oil and tempera on panel, 30 × 40 cm
Purchased, 1940 [1940.21]
Brown 22; Lister 215

Among the most subtly coloured of Palmer's oils, this painting combines the pastoral sentiment of Shoreham with the topography of 'dear, spongy Devon', which Palmer visited in 1834. Although the precise site has not been identified, the swelling hillsides, winding streams and distant views of the sea are typical of the North Devon coast. The *Pastoral Scene* was probably exhibited at the Royal Academy in 1835.

There are two related drawings (Yale Center for British Art and Tate Gallery), both in brown ink. Neither corresponds exactly with the painting, and Palmer probably made adjustments to the composition as he painted, which would account for the numerous *pentimenti*. He eventually sent it to Julia Richmond and her husband, William Fothergill Robinson, in 1874, noting that 'The "Harvest-field" sent herewith I have kept by me until now for occasional revision, and I do not see what more could be done without mixing styles or manners of working incident to different periods of one's life.'

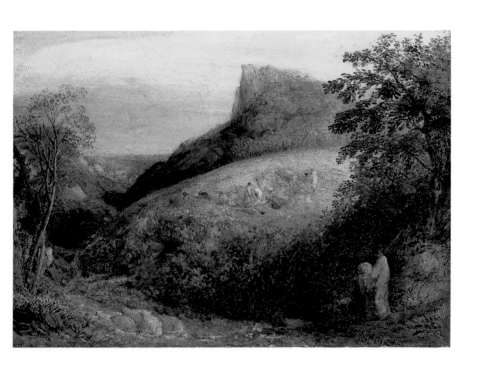

47

22 *A House and Garden at Tintern*
Pen and brush in brown ink, water and body colours
over pencil and black chalk on brown paper,
37.2 × 47.5 cm
Inscribed in ink on the old mount: *A Study at Tintern
drawn on the spot* and signed *S. Palmer*
Purchased, 1939 [1939.75]
Brown 23; Lister 232

Returning from a sketching tour in North Wales in sum-
mer, 1835, Palmer stopped at Tintern, where he was
enthusiastic about the abbey, 'set like a gem amongst
the folding of woody hills'. After visiting the abbey on
19 August 1835, he noticed a man '"literally sitting
under his own fig tree" whose broad leaves mixed with
holyoaks and other rustic garden flowers embowr'd his
porch.' He must have stopped to sketch the cottage on
this day or soon afterwards, for he very quickly ran out
of money and had to return to London.
 As the extensive inscription in the lower left cor-
ner indicates, Palmer was here concerned with minute
variations in light and texture, and the drawing displays
the almost obsessive attention to detail he had previ-
ously applied at Shoreham. Each species of flower is
carefully distinguished, from the fig tree to the pink
roses and hollyhocks in front of the cottage door. The
swirling penwork covering the foreground is breathtak-
ing, and much of the paper is left bare. The blue wash in
the sky scarcely conceals a closer view of the roof,
which Palmer must have quickly abandoned to create
this more distant view.

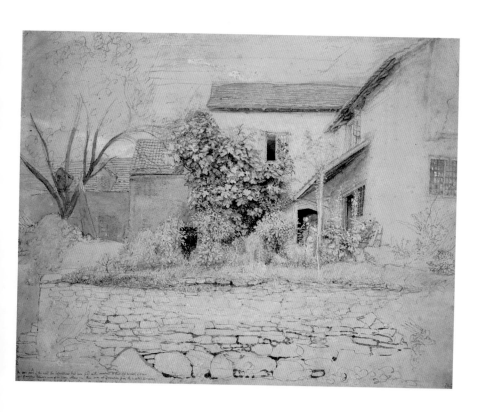

23 *Study of Trees*
Water and body colours over indications in black chalk
on greyish paper, 27.3 × 37.7 cm
Bequeathed by Mrs H.F.Medlicott, 1950 [1950.28]
Brown 24; Lister 205

One of many studies of trees, this was probably made in
the mid-1830s, before Palmer left for Italy. He has used
a different technique for each tree, and pure body col-
our for the foliage in the foreground.

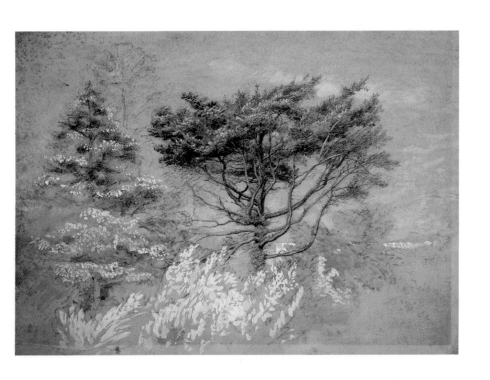

24 *Sunset at Corpo di Cava*
Watercolours over pencil and pen and brown ink,
heightened with gum, 14.3 × 19.9 cm
Bequeathed by Miss Philothea Thompson, 1995
[1995.199]

Palmer married Hannah, the daughter of John Linnell,
on 30 September 1837, and the couple spent the follow-
ing two years on an extended honeymoon in Italy. The
country delighted Palmer, who declared that 'Much as I
love England, I think every landscape painter should see
Italy. It enlarges his IDEA of creation and he sees at least
the sun and air fresh as from the head of their maker.'
The Palmers made their base at Rome, but travelled as
far as Florence and Naples, making copies after the Old
Masters for John Linnell, and selling an occasional orig-
inal of their own.

They were at the 'most delightful spot' of Corpo
di Cava, outside Naples, between 3 August and 9 Oct-
ober 1838. Palmer felt 'much enlargement' 'from an
awakening of the mind: the dispersion of a cloud of
doubt and anxiety, and a flow of imagination in the
choosing and treatment of my subjects.' Among many
drawings and sketches made here was one that after
Palmer's death, Hannah gave to Richmond Seeley, ex-
plaining that 'it was taken at Corpo di Cava at the latter
end of the summer of 1839 [1838], from a spot halfway
up the side of the Monte Finestra – so named on account
of the fine view it affords of the Paestum Valley. My hus-
band was engaged upon a larger drawing from the
point of view on the evening of the wonderful sunset
which lighted up the mountains with a crimson glow. I
was with him at the time, and well remember his excla-
mations of delight at the glorious spectacle.'

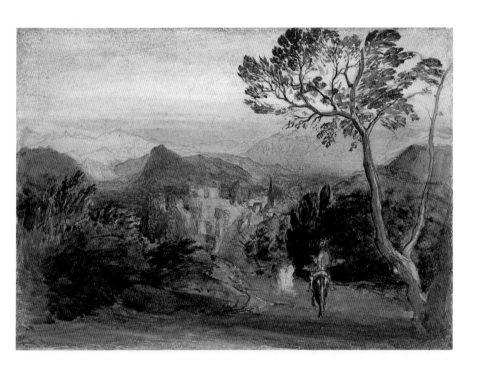

25 *The Villa d'Este at Tivoli*
Water and body colours with some pen and ink height-
ened with gold over pencil on buff paper,
33.5 × 50.4 cm (IMP)
Purchased, 1940 [1940.65]
Brown 26; Lister 333

From Corpo di Cava, the Palmers moved to Tivoli,
where they remained for some weeks. They found the
Villa d'Este 'inexhaustible', 'enchantment itself – the
grounds are small but have work for months . . . one
might wear out a shop-full of hobnailed boots tramping
about England or Wales without finding such things.'
Unfortunately, for much of the time, the weather was
damp, and Palmer went out sketching 'armed in double
stockings, waterproof cloak and a flannel petticoat,
worn inside, of course.' He was principally engaged on
two large drawings, described by his wife as 'a very rich
drawing; foreground and all, just as it is in nature, of
Pines, Cypresses, with the picturesque town of Tivoli –
the Campagna and Rome in the distance; also another
of the Villa itself seen through those wonderful trees
looking like a palace of Heaven.' The former was prob-
ably this view, which Palmer intended to exhibit in
Rome in the vain hope of attracting a buyer. It was pre-
ceded by a magnificent study of the cypresses (Yale
Center for British Art, New Haven), which recalls Rus-
kin's praise in *Modern Painters* for this 'faithful follow-
er of nature . . . his feeling is as pure and grand as his
fidelity is exemplary.'

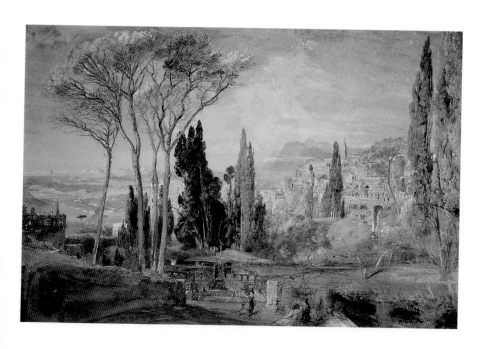

26　*The Colosseum and Alban Mount*
Water and body colours over pencil, black chalk and
pen and brown ink, heightened with gum, and scratch-
ing out, 20.3 × 39.9 cm
Purchased, 1942 [1942.114]
Brown 25; Lister 384

While the Palmers were at Rome, they both worked
hard, copying the work of the Old Masters for John
Linnell, and studying at first hand the landscapes they
already knew from the paintings of Claude and Turner.
During this time, Palmer was engaged on several large
views of Rome, which he hoped to sell to English tour-
ists. However, he lacked the charm and social circle of
his contemporaries, Edward Lear and J.F.Lewis, and
was always short of money. He sent two large water-
colours, of *Ancient Rome* and *Modern Rome*, to the
Royal Academy in 1838, hoping to gain a reputation for
such work, but only one commission materialised, for a
replica of *Modern Rome* for the celebrated collection of
Sir Thomas Baring.

On his return to England, Palmer continued to
exhibit Italian views at both the Royal Academy and the
Old Watercolour Society. He was even able to work up
his Italian sketches into five illustrations for Dickens's
Pictures from Italy, published in 1846. This view of *The
Colosseum and Alban Mount* may have been exhibited
at the Old Watercolour Society in 1843. It was based
on an almost identical view sketched on the spot and
lightly coloured in watercolour (Tate Gallery). For the
repetition made in London, Palmer has abandoned
spontaneity, using bodycolours applied in a slightly
finicky technique to give substance to his exhibition
piece. The foreground is entirely imaginary, and adds a
timeless female figure and a herd of goats to emphasise
the classicism of the scene.

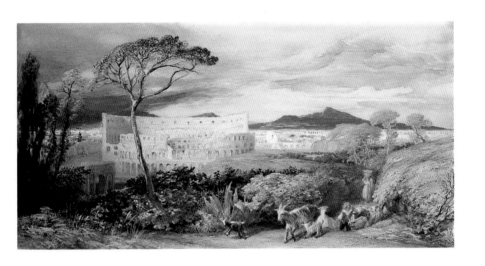

27 *A Farm Yard at Princes Risborough*
Water and body colours and pencil with scratching
out, 26.8 × 36.8 cm
Bequeathed by the Revd William Fothergill Robinson,
1929 [1929.35]
Brown 29; Lister 402

During the 1840s, Palmer continued his intensive sket-
ching expeditions in the summers, and exhibiting the
results at the Old Watercolour Society in the autumn. At
the exhibition of 1845, he sent seven Italian subjects,
and the following year seven English. He made his base
in summer 1845 at Margate, with over a month at
Collins's Farm, Princes Risborough, where he made a
'batch of Imitation'. This watercolour is one of two
views of the farm; the other, more finished and from a
more obviously picturesque viewpoint, was exhibited in
1846 (now in the Victoria and Albert Museum).

From extensive notes he made at the same time, it
is clear that Palmer was once again reconsidering the
means of achieving his intentions. He vowed, for exam-
ple, to eschew the hot colouring of his early work, for
'the use of a violent colour immediately shocks one, and
it [should be] dappled about and melted into delicacies.'
A Farm Yard at Princes Risborough illustrates some of
his concerns: the bright colours in the foreground have
been toned down, and the brilliance of the sky has been
muted in purple washes. The minute stippling, however,
is a return to the technique familiar from before Pal-
mer's honeymoon, but it is now used to convey a much
more sophisticated effect of chiaroscuro.

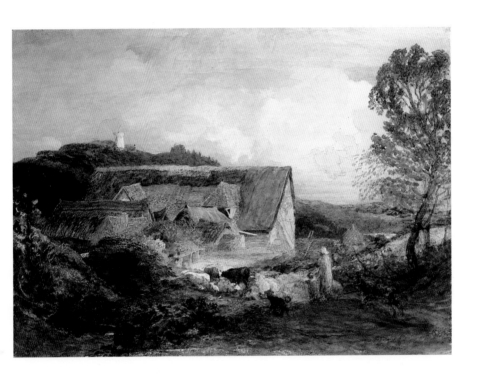

28 *At Redhill*
Water and body colours over black chalk on buff
paper, 25.9 × 37.6 cm
Bequeathed by Mrs H.F.Medlicott, 1950 [1950.29]
Brown 30; Lister 434

John Linnell moved to Redhill in Surrey in 1849, and
Palmer visited his father-in-law in that summer. He
made several studies of wooded landscapes at the time,
which closely resemble those of Linnell and of George
Richmond. This is a typically rapid production, with vig-
orous hatching in thick chalk, and full use made of the
tinted paper.

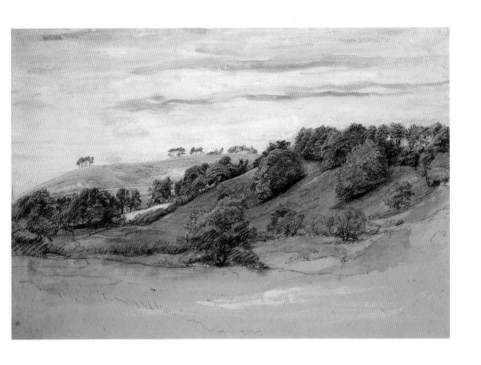

29 *Study of Trees, Clovelly Park*
Black chalk on greyish paper, 25.5 × 37.1 cm
Purchased, 1954 [1954.97]
Brown 32; Lister 199

After his first visit to Devon in 1834, Palmer returned
frequently. He made an extended stay at Clovelly in
1849, where he made this sketch of trees, perhaps at the
place known as the 'wilderness where, in leafy alleys
and winding walks – you might fancy you were in Ken-
sington gardens'. At the left, there is a steep slope down
to the sea. The tangled branches of the trees, boldly and
rapidly drawn in black chalk, are as mysterious as those
in the Dell of Comus, which Palmer later portrayed in
his illustrations to Milton.

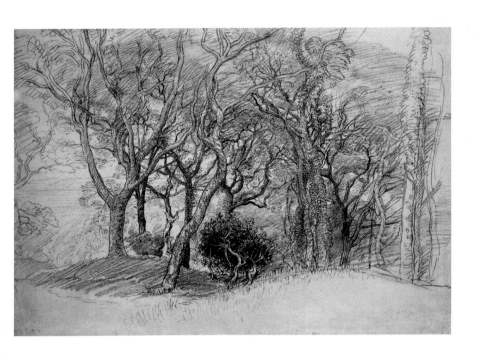

30 *The Wooded Lane*
Water and body colours over pen and brown ink and
pencil, 37.6 × 50.7 cm (IMP)
Signed in brown wash, lower left: *S. Palmer*
Bequeathed by Mrs H. F. Medlicott, 1950 [1950.31]
Brown 33; Lister 464

During the 1840s and 1850s, Palmer exhibited numerous
rather conventional pastoral scenes at the Old Water-
colour Society. Many depict an idealised vision of rural
England made popular by Gainsborough and others in
the eighteenth century. *The Wooded Lane* is one such
work, showing a cow and two goats ambling before a
peasant girl carrying a child and a picturesque old
crone. Although it cannot be identified with any exhib-
ited work, its size and technique are similar to several
others, such as *Crossing the Ford*, shown at the
O. W. C. S. in 1846 (private collection; Lister 415). Indeed,
it may be the *Lane Scene* shown in the same exhibition
and otherwise unknown.

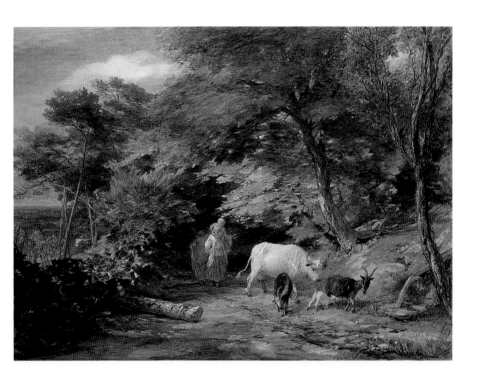

31 *Christian descending into the Valley of Humiliation*
Water and body colours with gum arabic and gold
over indications in black chalk, 52 × 71.2 cm (IMP)
Bequeathed by the Revd William Fothergill Robinson
through the National Art Collections Fund, 1929
[1929.35]
Brown 35; Lister 444

Palmer had read Bunyan's *Pilgrim's Progress* from his
childhood, describing it to a friend as 'a *charming* book,
full of artless pathos which brings tears into the eyes
unawares and one hardly knows why. Both the first and
second parts are incomparable as books to read to
children, while the oldest and wisest man can never
become too old or wise for them.' This watercolour
illustrates the episode when Christian, having left his
family in the City of Destruction, is armed and descends
into the Valley of Humiliation; beyond are the Valley of
Death, the shepherds on the slopes of the Delectable
Mountains, and the Celestial City, Christian's ultimate
goal, lit by the sun in the distance. Palmer's treatment of
the scene is unusually dramatic, the grandly Romantic
sky and effects of light worthy of Turner. The figure of
Christian resembles classical heroes such as Aeneas in
Claude's landscapes, while the Italianate tower, presum-
ably part of the Palace Beautiful, is one Claude and Pal-
mer might have found in the Tiber Valley.

 This magnificent work was exhibited at the
Old Watercolour Society in 1848, but, in A.H.Palmer's
words, 'returned unsold . . . to take its place with those
unfortunates a few of which many a discouraged artist
hides away from his own and other people's sight.'

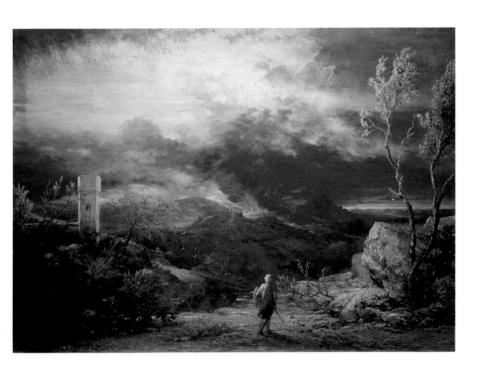

32 *The Water Mill*
Water and body colours with gum arabic and scratch-
ing out, 51.2 × 71.2 cm (IMP)
Presented by the Revd William Fothergill Robinson in
memory of Alfred and Mary Eleanor Robinson, 1925
[1925.12]
Brown 34; Lister 443

Palmer's restless search for new means of expression
led to experimentation with a variety of styles in the late
1840s. *The Water Mill* is roughly contemporary with *Tin-
tagel Castle* (no. 33), but painted in a broad, loose style
quite different from the minute stippling of the latter.
Palmer was pleased with the new manner, and believed
that he had 'made a great advance in the estimation of
artists by my mottled sky drawing begun at Margate',
which elsewhere he affectionately called the 'Margate
mottle'. The subject is once again a tranquil scene at
twilight; a female figure reclines gracefully on the banks
of the stream, watching the cows drinking. Behind the
mill, tall trees are silhouetted in a delicate yellow-brown
against a pale sunset. This large piece is boldly painted
in translucent watercolours, the saturated washes of the
trees heightened with gum, and the reflections of the
water, and the shape of the mill wheel, achieved by
scratching through to the paper beneath.
 It was preceded by a small and vigorously drawn
chalk sketch, in which the sky appears as evenly drawn
rows of blue and mauve, with the clouds left blank (pri-
vate collection).
 Despite the esteem of his friends, Palmer was
again unable to sell this work.

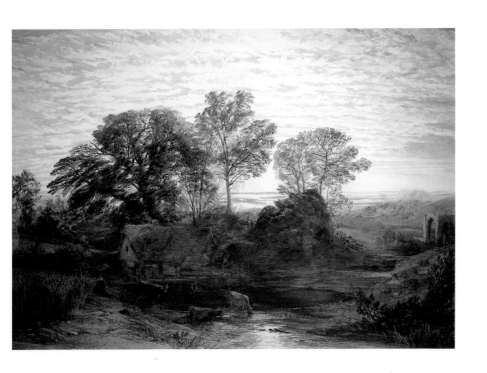

69

33 *Tintagel Castle; approaching Rain*
Water and body colours with gum arabic over pencil,
black chalk, and pen and brown ink, 30 × 44 cm (IMP)
Presented by Percy Moore Turner, 1942 [1942.27]
Brown 31; Lister 453

While on a sketching expedition to Cornwall in July,
1848, Palmer wrote to Edward Calvert that 'the north
Cornish coast is very wild, but the country above tree-
less and desolate. There is one most curious place on the
peaks of two cliffs, which are gradually tumbling by
huge fragments into the sea, viz. Tintagel Castle, the
birth-place and palace of King Arthur. It was a moul-
dered ruin in the days of Henry the Eighth. Some tur-
reted fragments remain which are very quaint and
strange.' He made several sketches of the 'mysterious
and clueless' ruin, the remains of the castle built by
Reginald Earl of Cornwall, the bastard son of Henry I,
with romantic associations of King Arthur, Merlin and
the Knights of the Round Table. This magnificent draw-
ing, one of the most successful of the artist's maturity,
was preceded by a bold sketch in chalk and watercolour
(British Museum), and is reminiscent of Turner's water-
colour of the same subject, which was engraved by
Palmer's friend, George Cooke, for *Picturesque Views
on the South Coast of England*. The painstaking stip-
pling, some probably achieved with a sponge, is used
both to differentiate textures and to give unity to the
earth, sea, sky and squall of rain, and creates an impres-
sion of the sublime in keeping with the subject.
 This drawing was probably exhibited at the Old
Watercolour Society's exhibition in 1849.

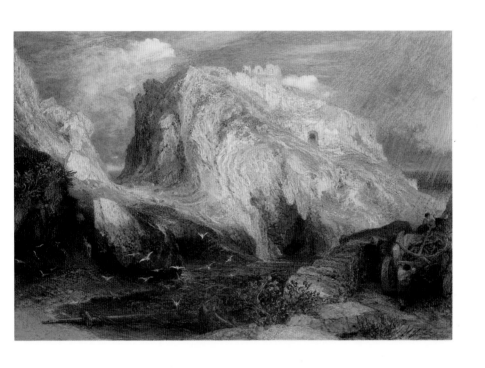

34 *The Willow*
Etching, 9 × 6.7 cm (image), 11.7 × 8.2 cm (plate)
Purchased, 1954 [1954.110]
Lister 1, state II

Palmer turned to etching comparatively late in his career, probably owing to his dissatisfaction with painting. Indeed, he ruefully noted that 'if this kind of needlework could be made fairly remunerative, I should be content to do nothing else, so curiously attractive is the teazing, temper-trying, yet fascinating copper.' In fact, he worked only intermittently in the medium and completed a mere thirteen plates before his death in 1881.

He made his first plate, *The Willow*, in 1850, and on its strength was elected to membership of the Etching Club. This gentle scene of high summer, with fluffy clouds in the sky and cows watering in the shade of the willow, is a direct copy of a watercolour, probably made some years earlier (now in Manchester City Art Gallery).

All Palmer's etchings are heavily worked, as was the fashion among members of the Etching Club. He defended this practice warmly: 'Somehow or another, I fancy we have all of us more or less the notion that because an etching should be spirited it should be done in an hurry. I grant that there is a sort of vigour and a very agreeable texture got in this way, which delights the eye for a short time, but beyond which the work never grows upon us: but Rembrandt's, many of whose etchings are, in the leading points, very highly finished, which he was constantly revising, sometimes to the extent of organic changes, retain their hold long after the first ocular pleasure is over.'

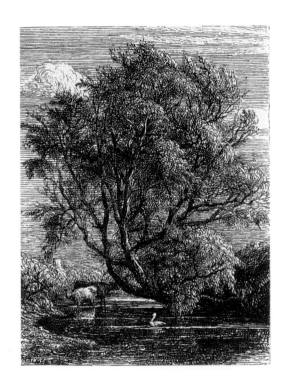

35 *The Morning of Life*
Etching, 13.6 × 20.8 cm (image), 18.1 × 25.8 cm (plate)
Signed within the plate, lower left, *S.PALMER*
Signed in pencil, lower right, *S.Palmer* and inscribed,
Trial Proof
Presented by Arthur Mitchell, 1964
Lister 10, state III

According to the artist, this etching was begun in
1860–61 'to illustrate a classical subject; but finding that
I could no-how clip my poodle into lion-shape, I even let
the hair grow, and christened him for the *Art Union, The
Morning of Life'*. The plate was eventually published in
*Etchings for the Art Union of London by the Etching
Club*, 1872.

36 *The Bellman*
Etching, 16.7 × 23.5 cm (image), 19.2 × 25.3 cm (plate)
Inscribed in the plate: *S. PALMER INV. ET. FEC*
MEAD. VALE RED HILL 1879
Lister E11, state VI

Palmer had admired the poems of Milton since his child-
hood, and knew the lighter works, *L'Allegro* and *Il Pen-
seroso*, by heart. He conceived the project of illustrating
them in the 1840s, but it was not until 1863, when Leon-
ard Rowe Valpy, Ruskin's solicitor, commissioned the
artist to paint something speaking to his own 'inner
sympathies', that work began in earnest. The result was
a series of large watercolours, which Palmer worked on
until his death, and which he intended to translate into
etching. Eventually, he completed eight watercolours,
but only two etchings, *The Bellman* and *The Lonely
Tower*. The watercolours were reproduced by photo-
gravure in *The Shorter Poems of John Milton with
Twelve Illustrations by Samuel Palmer Painter & Etcher*
in 1889, with Palmer's descriptive captions, written at
Valpy's request, opposite each illustration.
 The Bellman illustrates the lines 'Or the belman's
drousy charm, To bless the doors from nightly harm.' (*Il
Penseroso*, ll. 83–4). Palmer's commentary reads: 'Seclu-
sion without desolateness is aimed at here, and dark-
ness without horror. While light enough is left to show
that a village is comfortably sheltered, and that the
ground heaves well, and is richly wooded, increasing
gloom sometimes enforces the sentiment of exuberance
by giving more play to the imagination. If, as Dr
Johnson fears, "there is always some melancholy in his
mirth," there is certainly no wretchedness in Milton's
melancholy.'

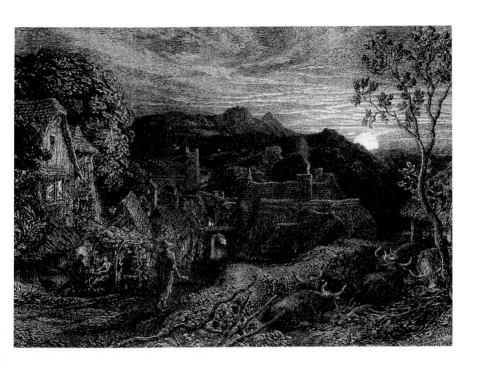

37 *The Lonely Tower*
Etching, 16.7 × 23.4 cm (image), 19.1 × 25.4 cm (plate)
Presented by Arthur Mitchell, 1964
Lister E12, state IV

The Lonely Tower illustrates the lines following those of
The Bellman:

> Or let my lamp at midnight hour,
> Be seen in some high lonely tow'r,
> Where I may oft out-watch the Bear,
> With thrice-great Hermes *Il Penseroso*, ll. 85–8

Palmer's commentary reads: 'Here poetic loneliness has
been attempted; not the loneliness of a desert, but a se-
cluded spot in a genial, pastoral country, enriched also
by antique relics, such as those *so-called* 'Druidic'
stones upon the distant hill. The constellation of the
'Bear' may help to explain that the building is the tower
of 'Il Penseroso.' Two shepherds, watching their flocks,
speak together of the mysterious light above them.'
 In his illustrations to Milton, Palmer consciously
sought to recapture the intensity of his Shoreham work,
and nostalgically described *The Bellman* as 'a breaking
out of village-fever long after contact – a dream of that
genuine village where I mused away some of my best
years, designing what nobody would care for, and con-
tracting, among good books, a fastidious and unpopular
taste.'

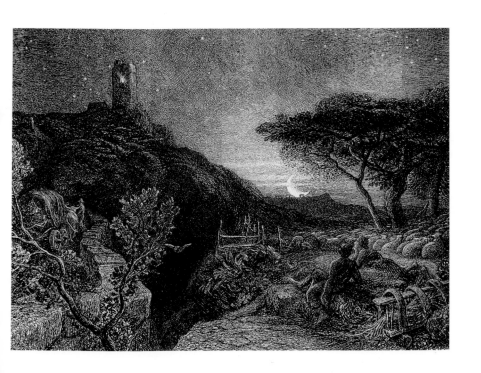

Suggestions for further reading

This handbook relies heavily on the work of David Blayney Brown, *Samuel Palmer 1805–1881: Catalogue Raisonné of the Paintings and Drawings, and a Selection of the Prints in the Ashmolean Museum* (Oxford, 1983).

Among other useful books are:
A.H.Palmer, *The Life and Letters of Samuel Palmer* (London, 1892)
Geoffrey Grigson, *Samuel Palmer: The Visionary Years* (London, 1947)
Lord David Cecil, *Visionary and Dreamer: Samuel Palmer and Edward Burne-Jones* (Princeton, 1969)
Raymond Lister, *Samuel Palmer: A Biography* (London, 1974)
The Letters of Samuel Palmer, ed. Raymond Lister, 2 vols (Oxford, 1974)
Raymond Lister, *Catalogue Raisonné of the Works of Samuel Palmer* (Cambridge, 1988)

In addition to that in the Ashmolean, the principal collections of Palmer's work are in the Fitzwilliam Museum, Cambridge; the British Museum, London; the Tate Gallery, London; the City Art Galleries of Birmingham and Manchester; and the Yale Center for British Art, New Haven, Conn., U.S.A.